The Brilliant Brush-Strokes of Autism

Volume I

Written and Illustrated by Ryan W. Tracy

AuthorHouse™
1663 Liberty Drive
Bloomington, IN 47403
www.authorhouse.com
Phone: 1-800-839-8640

Published by AuthorHouse 04/21/2015

ISBN: 978-1-4969-4856-4 (sc)
ISBN: 978-1-4969-4857-1 (e)

Print information available on the last page.

Any people depicted in stock imagery provided by Thinkstock are models,
and such images are being used for illustrative purposes only.
Certain stock imagery © Thinkstock.

This book is printed on acid-free paper.

authorHOUSE®

Contents

This book is dedicated

to my mom,

Elaine Roccos Mott

for being my advocate,

my inspiration,

my everything

The Red Jewel

Red vase of ruby jewels

I think you find joy in displaying your flowers

Quite a treasure they are for you to hold

I love the mighty red vase that tells the flowers to stand proud and tall

The flowers tell the vase to remain proud and regal

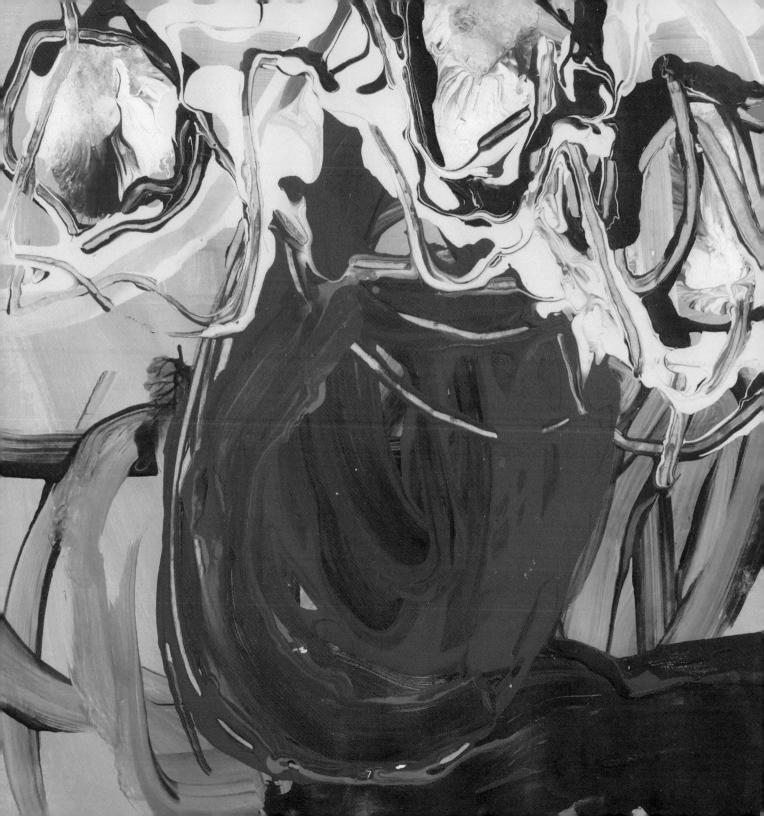

Flowers for me

Lovely pretty flowers I see,
standing in the vase staring at me
Gorgeous looking they stand so proud
Pretty they smell in my house

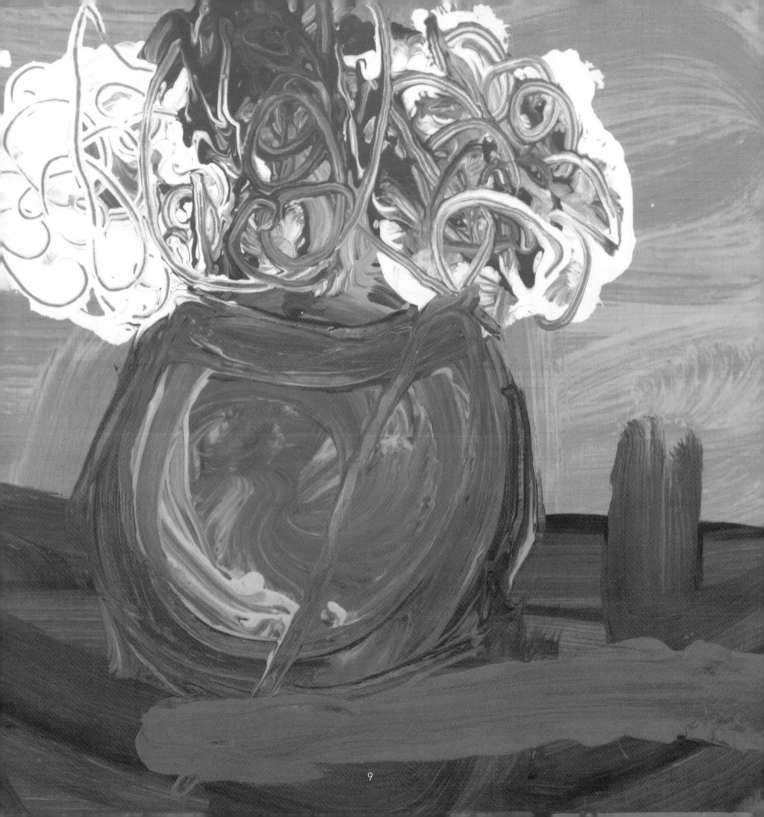

Ribbons of Color

Green acres fill my horizon

Dotted with white snowflakes like flowers

Ribbons of color draped across my panoramic vision

I long to run through the fields of green glory

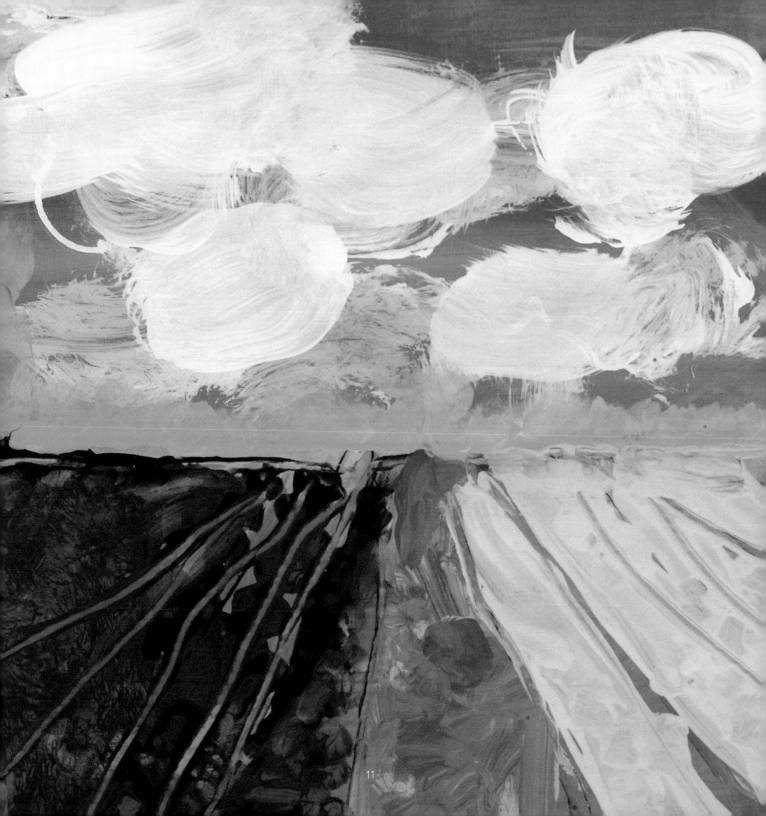

Beautiful Flowers Bloom in spring

Beautiful flowers bloom in the spring

They rise up like hands reaching towards the sun

People's faces smile when flowers arrive

Bees are always buzzing nearby

Children play like freed prisoners in spring

Spring is truly a magical thing

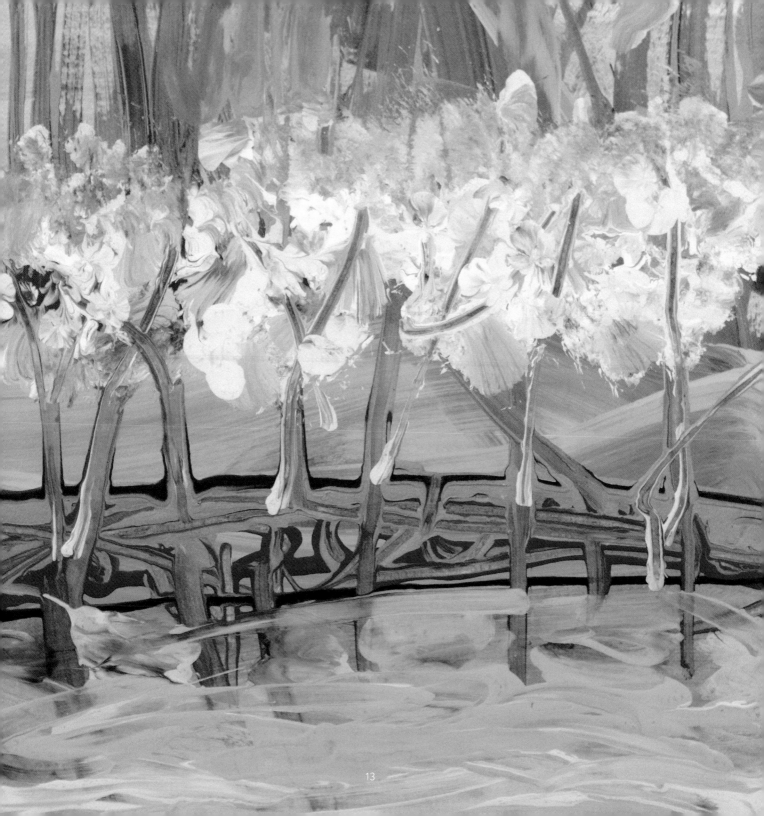

Flowers in the Fields

Fields of flowers red, yellow, purple and orange
Looking at me with their bright beautiful colors,
God has created just for me
Love all the colors with the blue rainbow clouds

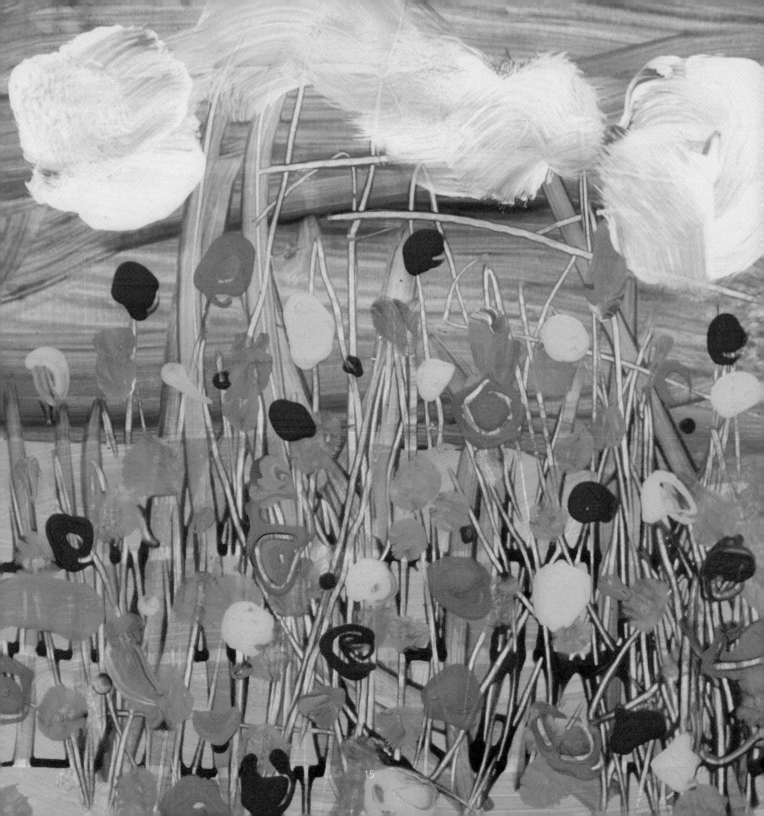

Purple Flowerz

They have a purpose
The individual beauty of each special flower fills
my soul with joyous wonder
Open buds of promise and hope
Anticipating the gift of visual feasting
People stop to smell me, they call out
Otherwise my life is without purpose
I find them calling out to me
I stop to admire their beauty

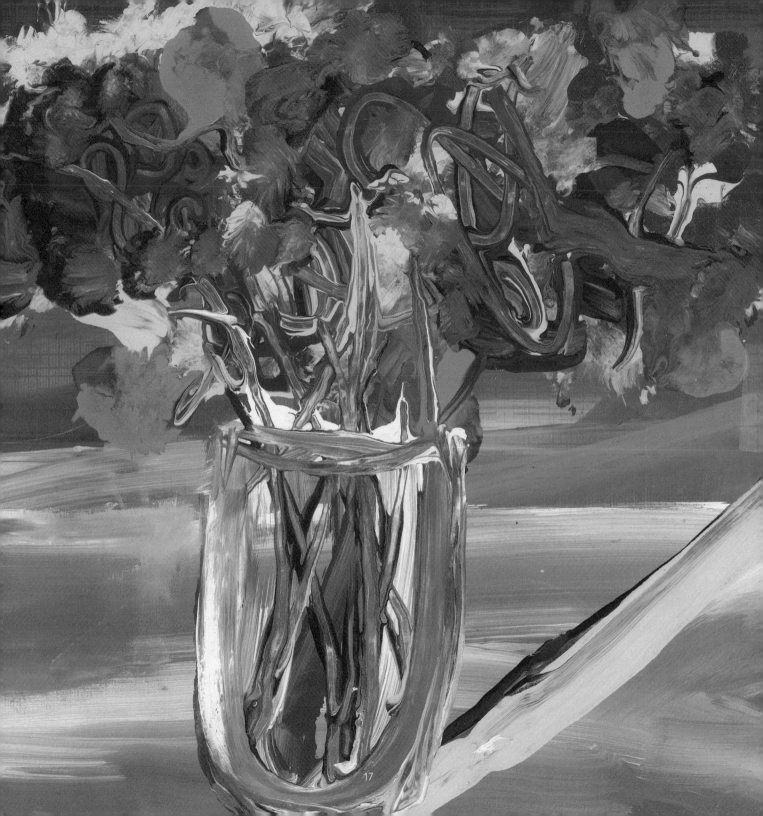

17

Favorite Time

My favorite time of year is spring
New possibilities arise
I love the fresh crisp morning air and the dew drops in the sky
Pretty flowers greet each day and bright colors are all around
People smile every day with all the beauty in the ground

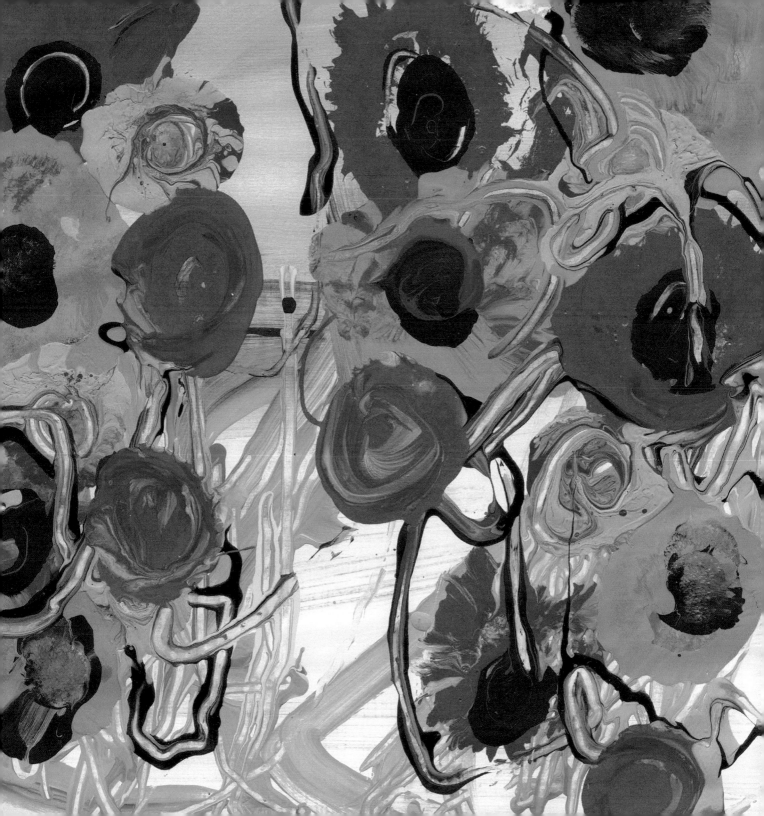

The Valleys of Hope

Hills of colored love spot the valleys

The green grass paints the canvas of my soul

The valleys of hope fill my future

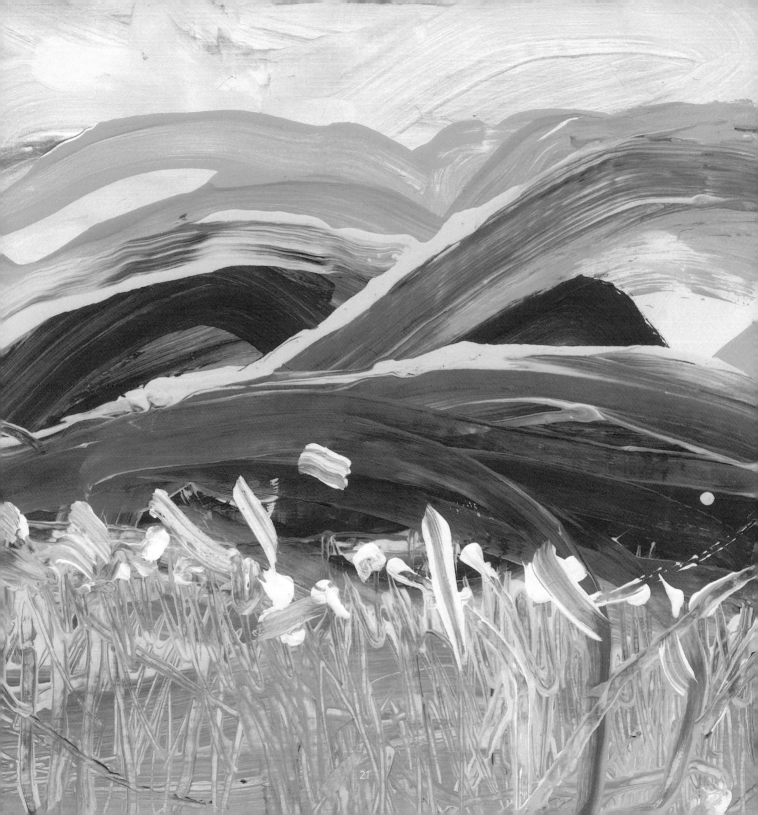

The Lone Tree

I am one for justice

One lone strong tree stands against the elements

One lone man stands out in the crowd

One person with autism stands for justice against all that is unknown

I am that lone tree for justice fighting for my silent brothers

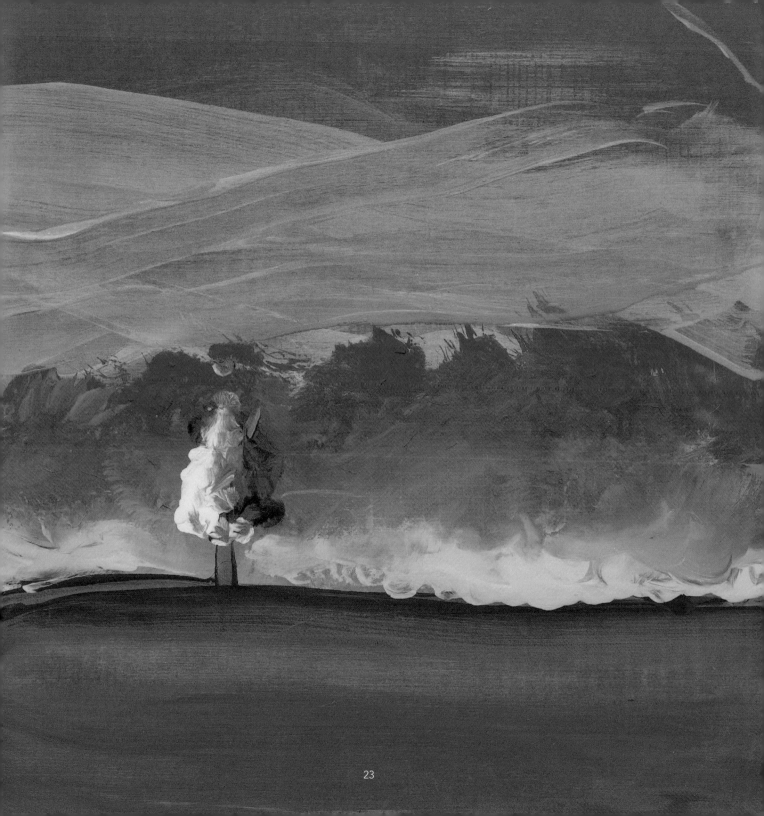

Blanket of Love

Amazing flowers spread over the horizon
Like a golden blanket of love
Keeps my mind warm with thoughts of God
Covering my soul in joy

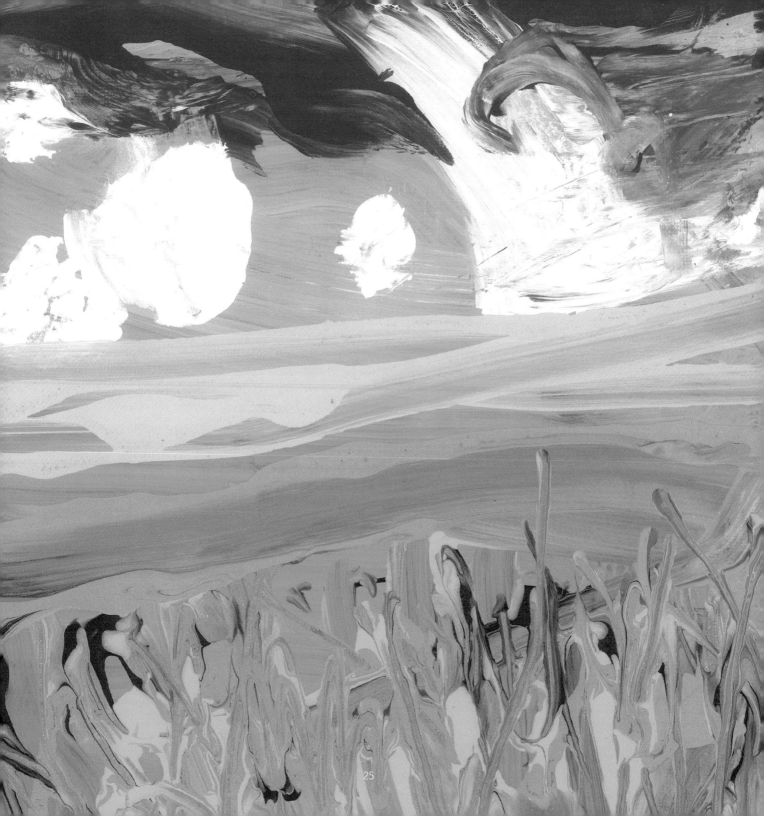

Paint It Again

Ready steady my paint brush is pretty full of thoughts
I apply the strokes and watch with a mind to appear what mind can use
Up comes a tree or a flower pretty easy
Then a flash of thought like a camera in hand
Change of direction, and I do it again

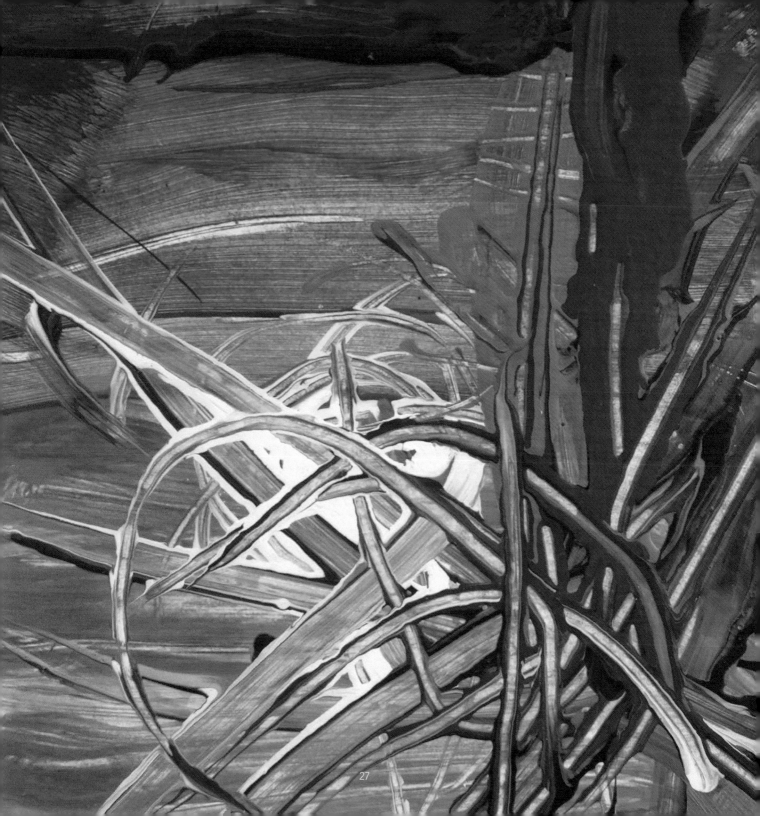

The Wild Me

The wildness of my soul finds its grace in the most creative ventures

The singular blowing tree bends but never breaks

Autism seeks to break my wild spirit from within

I stand strong in hurricane force trials that place storms at my branches

I refuse the call to quit

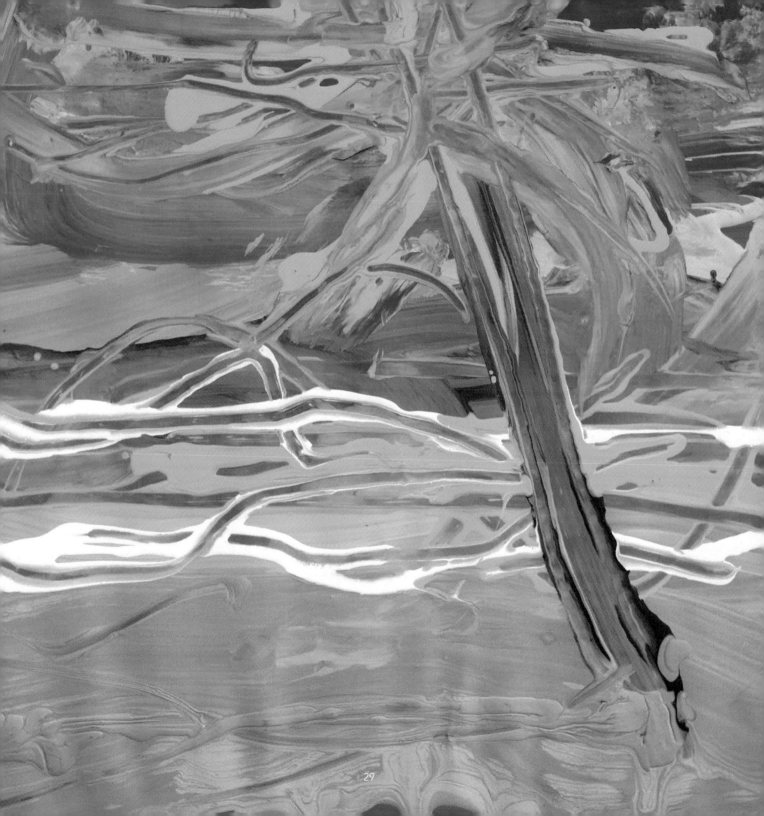

The River of Calm

Deep in the dark green forest of mind, I find a cool river of thought

Inside the chaos of fire neurons order prevails

I seek the river of calm when Autism strikes its storm

The forest is that which deeply saddens my soul

The river meanders its way like my life flows

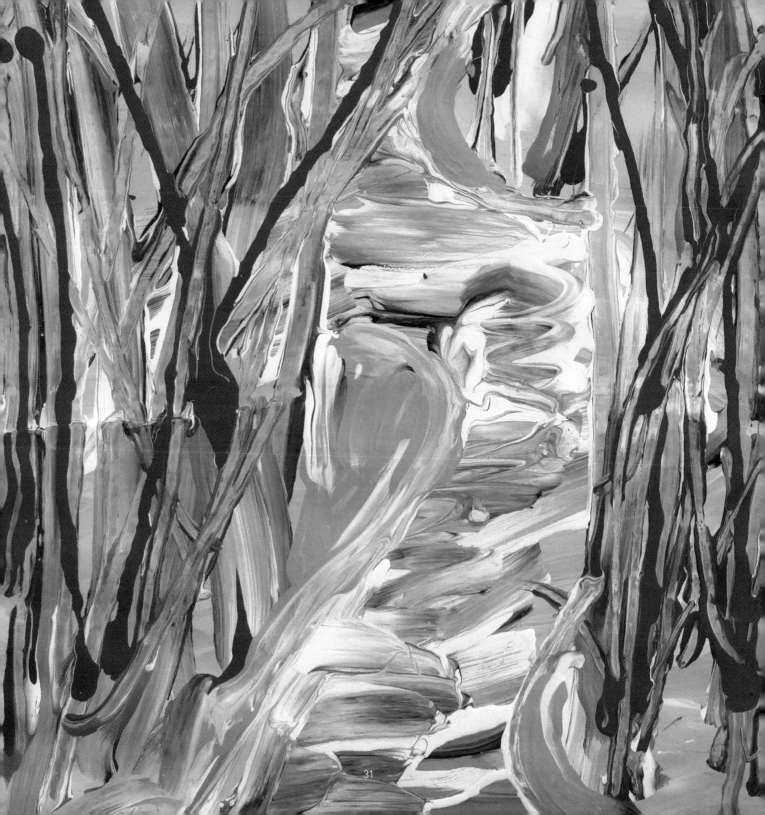

Lavenders Sweet Face

The purple fields of grace fill my senses with beautiful thoughts
I find my solace in the grace of lavenders smell
How perfect the flower stands reaching for God's face
I love the feel of the flowers touch in my hand
The scent soon washes over my soul
I touch heaven and thank God

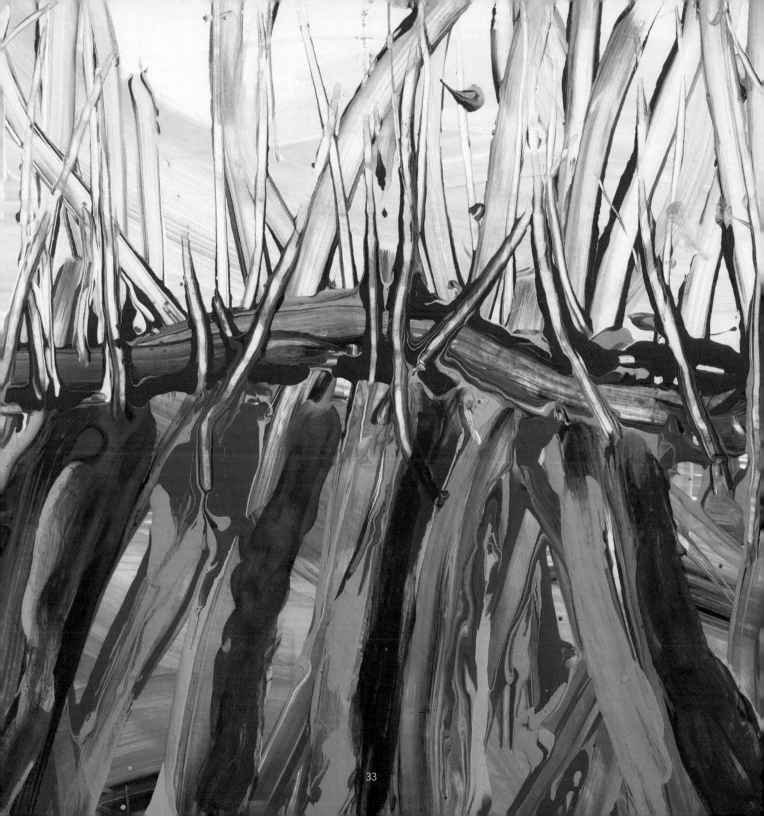

Three Red Jewels

Three red jewels as bright as rubies I see

They speak of beauty inside of me

They smell so sweet as I pass by

How grand a creation mother nature has brought forth

On this day they live inside a blue vase

I see them now in living color in my minds eye

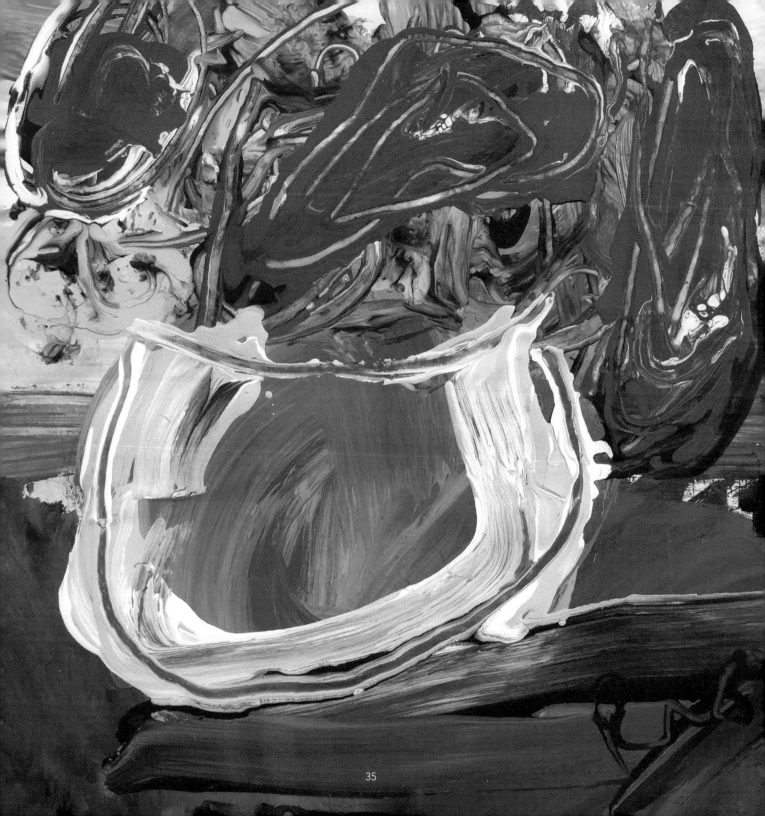

My Golden Hills

Golden California hills of beauty I see

Justice, Freedom, and Liberty

My country is a melting pot

People of all kinds find their futures here a lot

On poppy laden fields I roam

Where buffalo once made their homes

Indians lived and found beauty all around

I found my voice and purpose abound

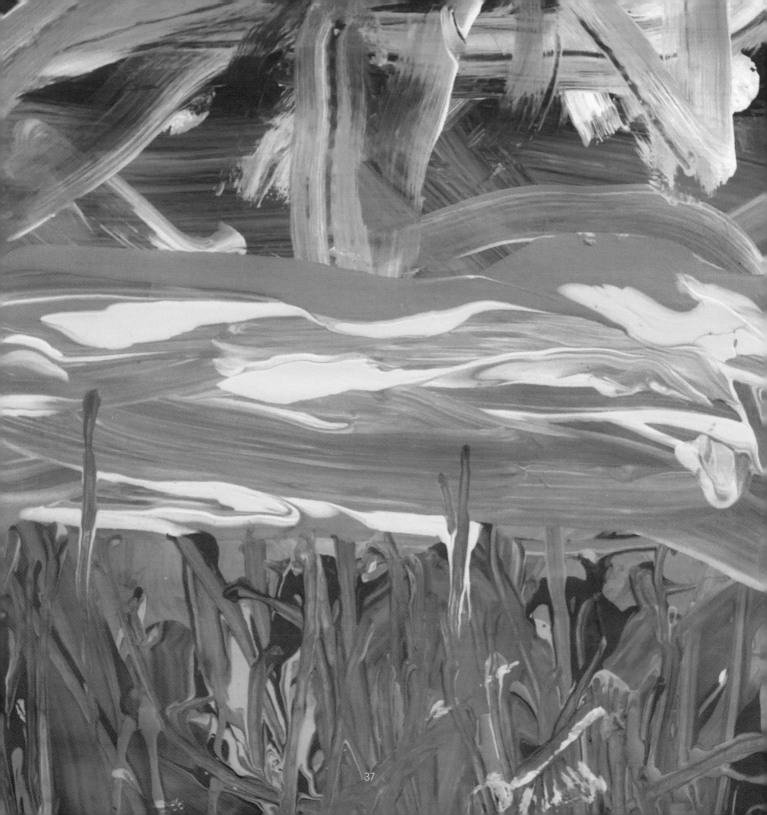

The War

The steel towers stand mighty in the face of ocean's waves

They challenge the mighty bridge of steel

I am the great ocean that can build high waves to erode your strength

The bridge answers back with its big tall towers, I cannot be moved

by the currents or waves

They battle on throwing their best shots, they stale mate

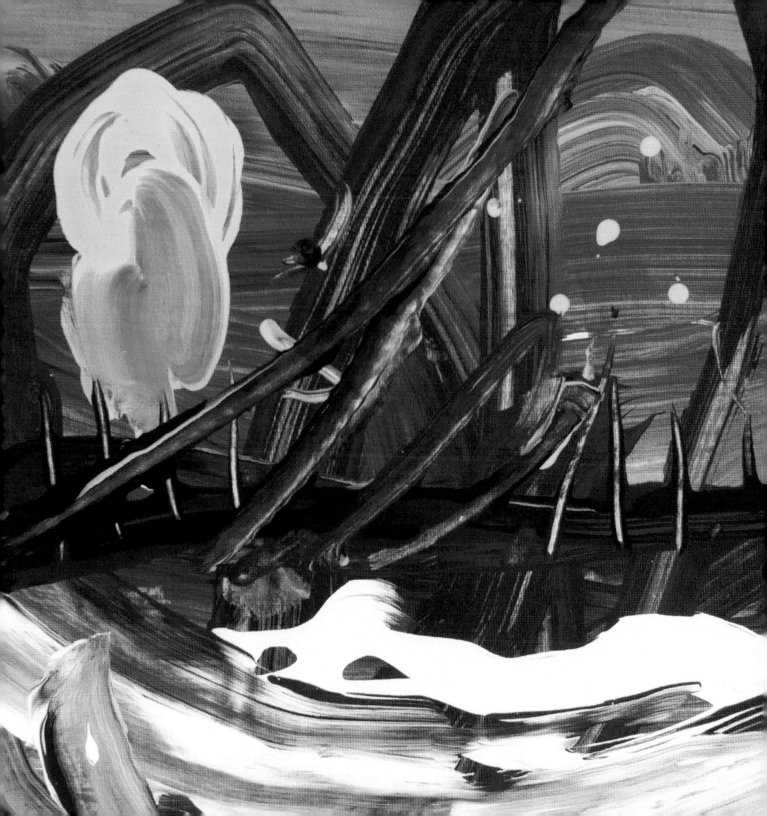

Trees of Glory

Trees of tall green beauty reach for heaven's glory
God's finest filter of air
Home to nature's animals
The beauty seen in parks as we stroll on by

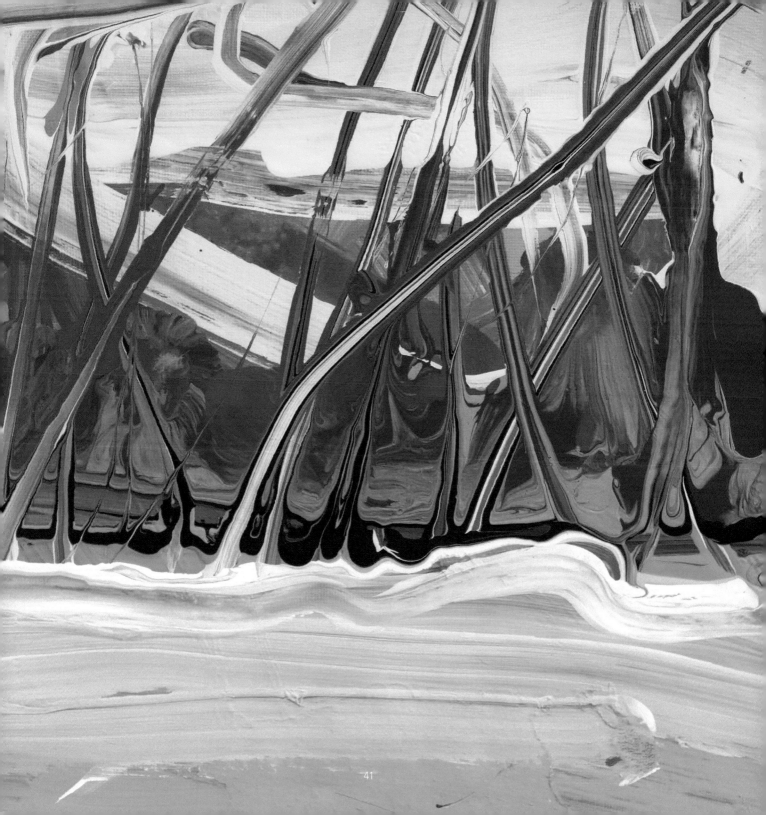

Blazing Flames in the night sky

Fire filled sunset reaches out to burn my heart

Blazing flames of glory fill my vision

Heated strokes of color fill my soul

A blue night sky to follow the flames

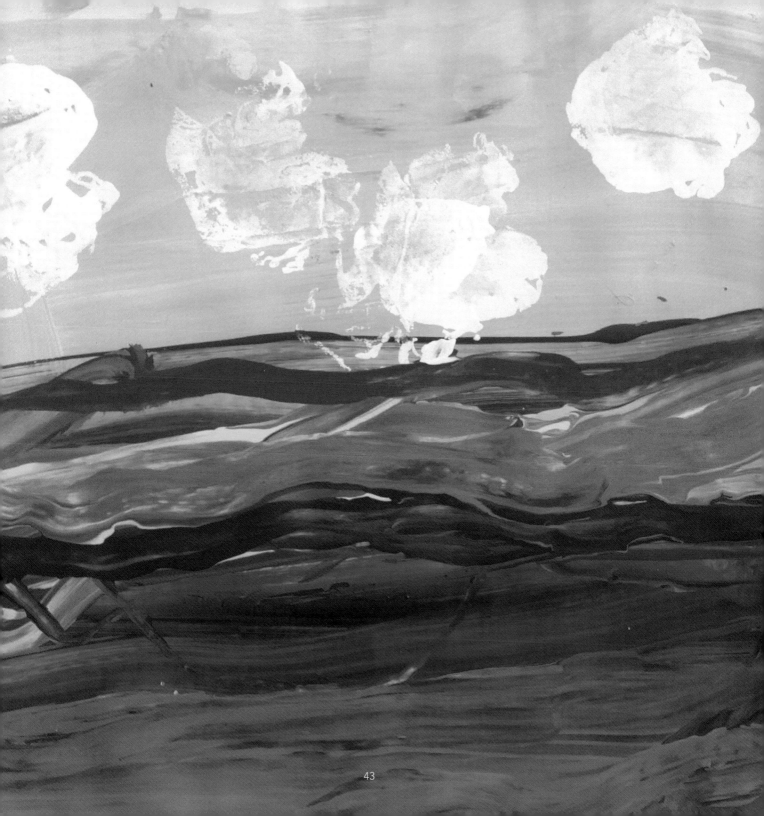

Spring is Here

Spring time sun shines through the rain
Butterflies tentatively fly overhead
Rainbows rise up high in the sky
My favorite time of year is here

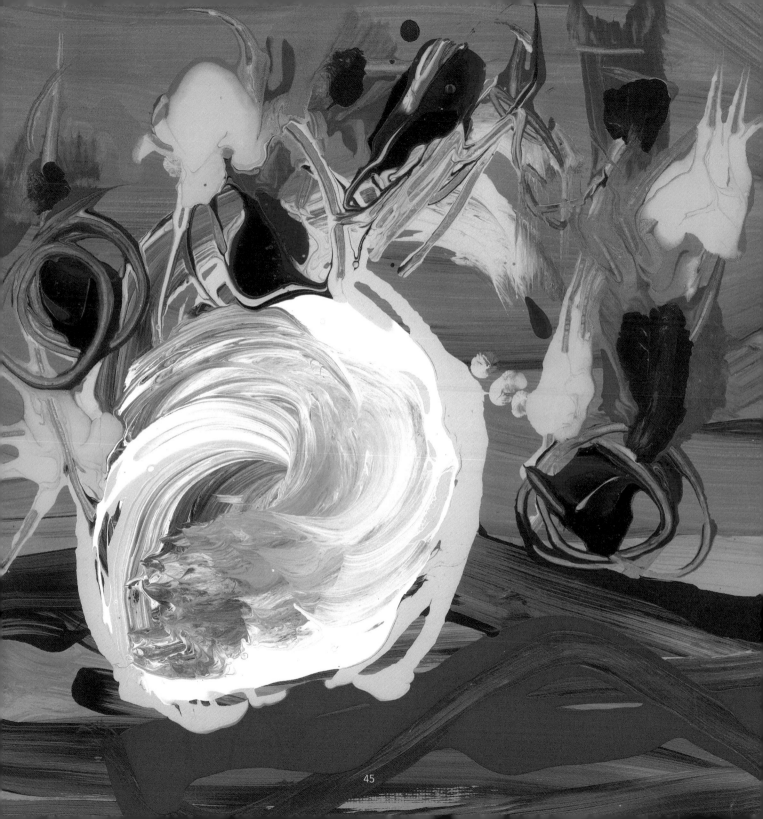

Enduring Desert

The desert heat is hell on earth

The mighty cactus forges on

It stands so tall shouting keep away, if you don't a prickle you will pay

It survives hells heat day by day

It helps animals through in many ways

The desert is a place for only forges on,

The desert is a place for only the strong

The mighty cactus is enduring it all

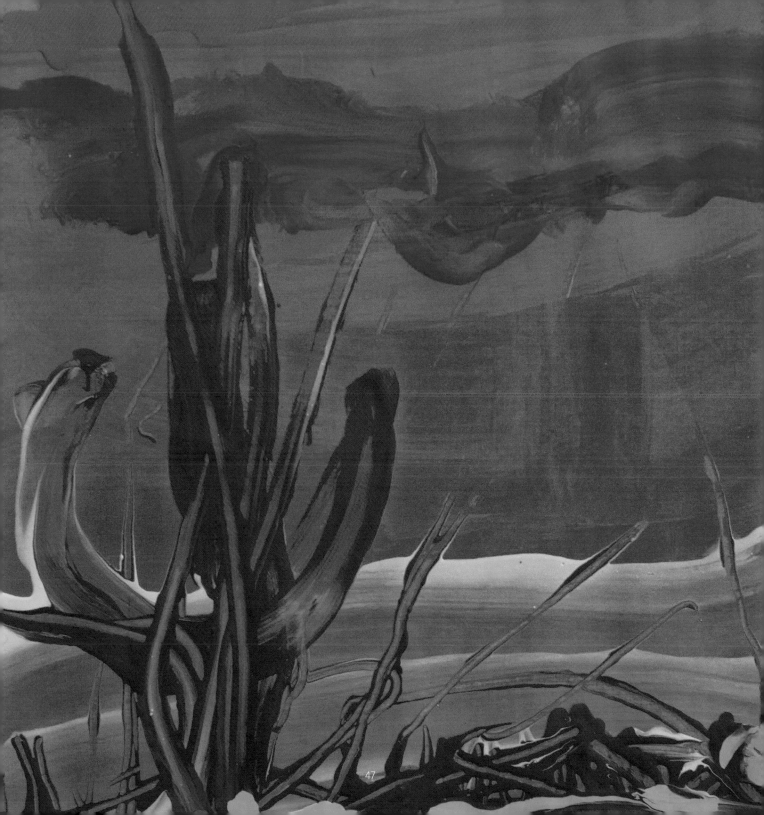

The Blue Hill Beach

Blue hill grasses blow with the winds soft kiss,

Beneath the waves gentle strokes

The songs of nature's soft whispers

The joy of natures hills and valley's vast oceans

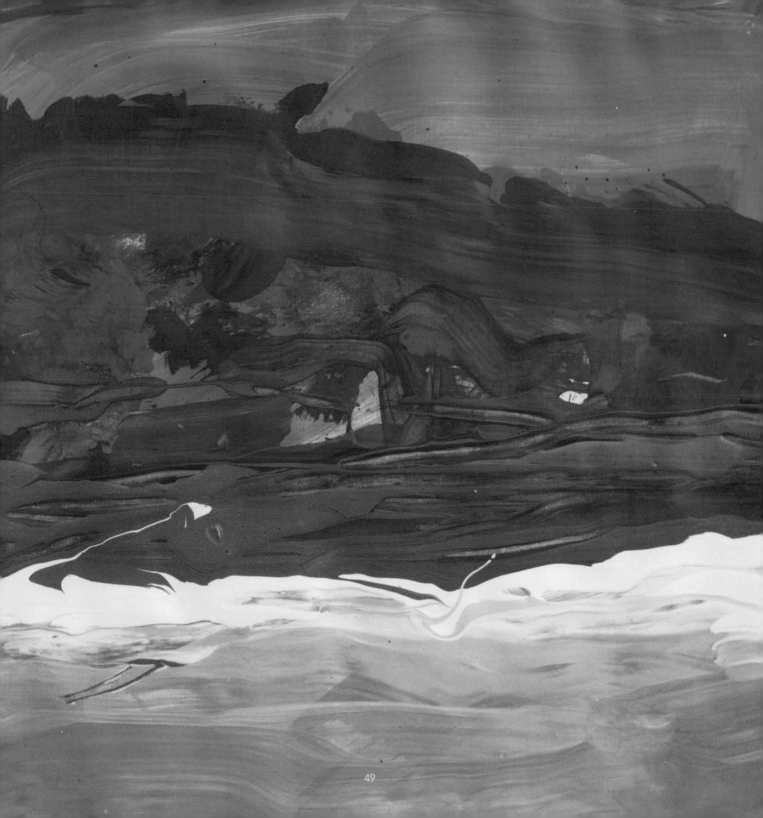

God's Video Gift

White fluffy cream puffs fill the sky with visual dreams
They float on by like pictures in a mind movie
The changing landscape is a moment in time
Laying back to enjoy God's video is a gift

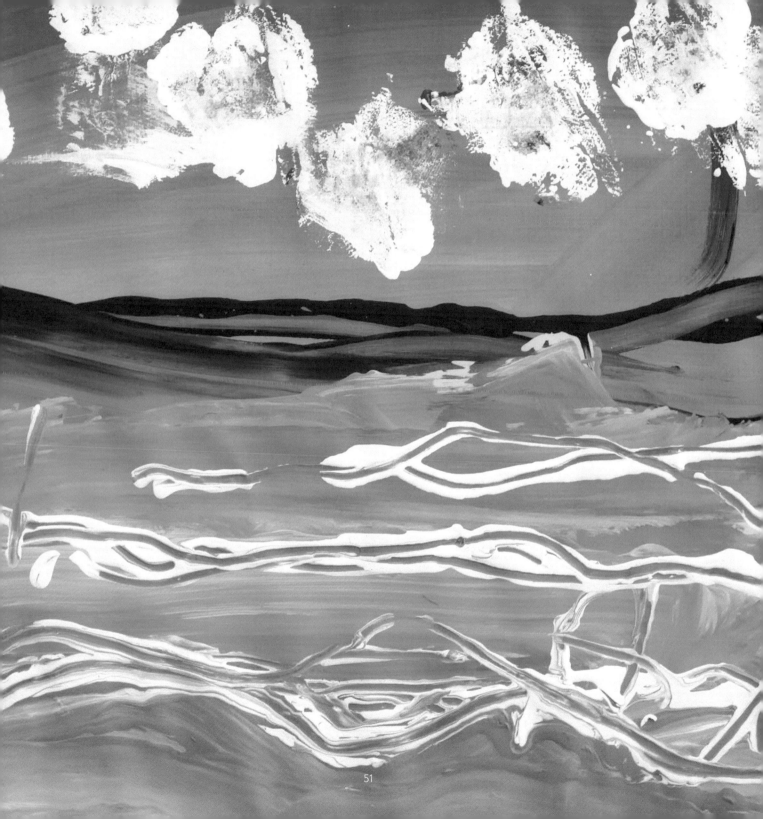

Black Eyed Beauties

Black eyed beauties calling out my name
Reaching their faces to kiss my cheek
Waving your stems to dance in unison
Lovely ladies hugging my soul

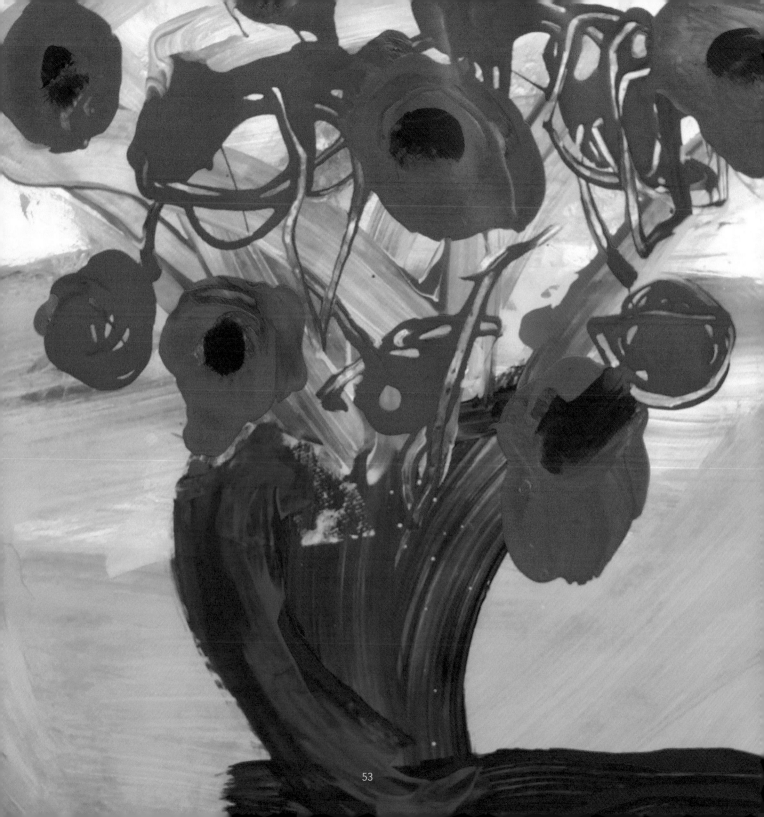

God's Creation

Hot cross pansies standing so tall
Facing the world like nothing is wrong at all
Colors so bright like the northern lights
Each a unique expression of God's creation

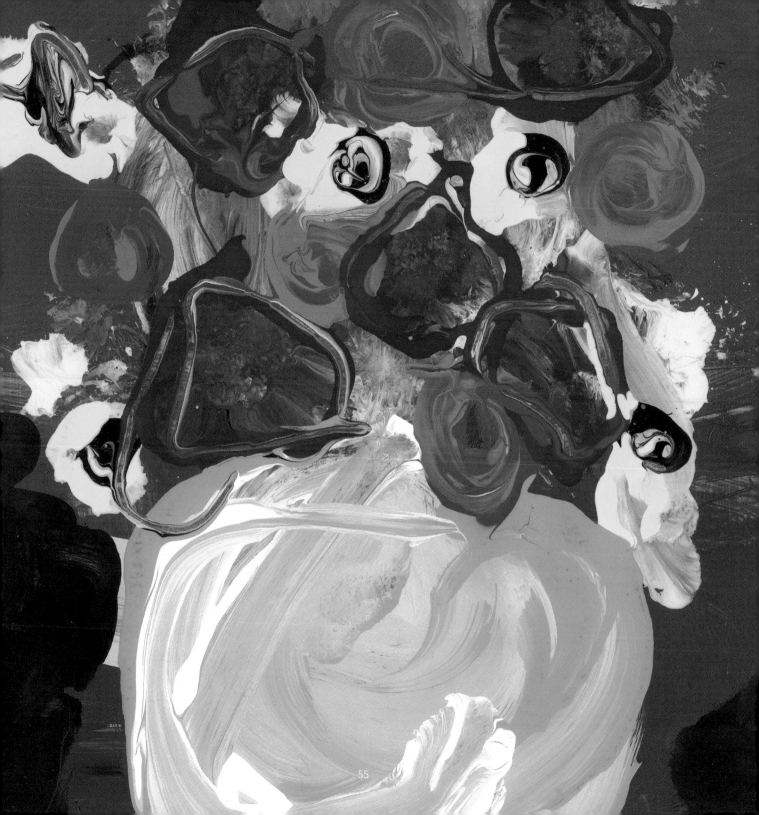

A Place of Grace

The flower garden is my place of refuge

I find solace in my refuge

I find peace there

I find hope there

Mostly, I find myself in my souls place of grace

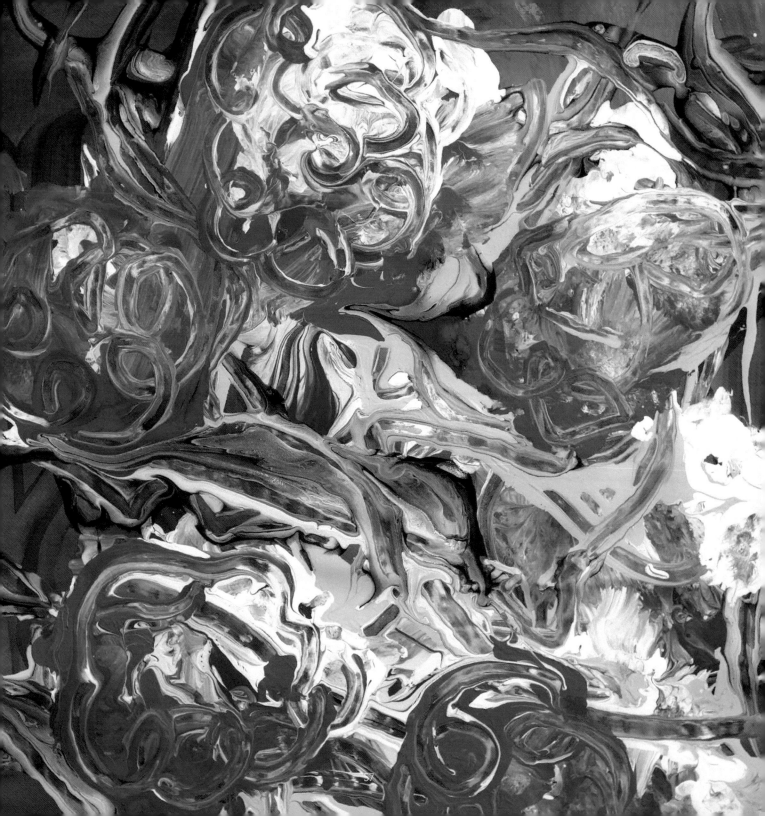

Painted Lovely Dreams

Visions of pink swirls in my mind

Red, purple and green dance across the canvas

I see beauty forming as my brush moves

Places from my dreaming thoughts find their way to my painted world

Painted dreams surround my thoughts

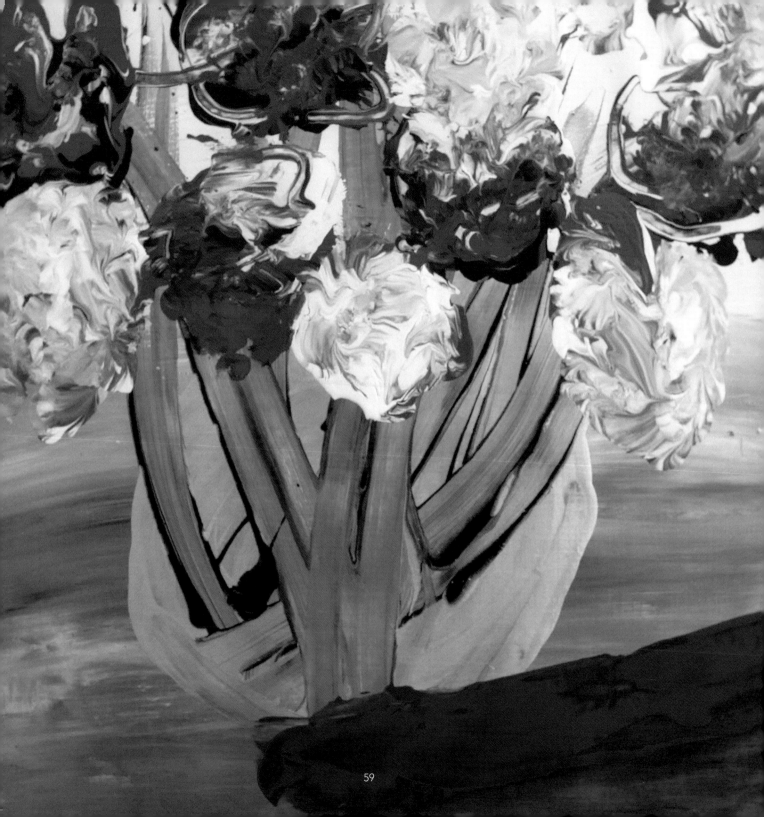

The Bouquet of Common Goals

Daisy one, daisy two, daisy red white and blue

They stand up strong like soldiers do

Fighting for what they believe in for me and you

They form a group like a regime

Together united, in one common goal

Together the daisies form a bouquet better in a group any day

The bouquet is a reminder of grouped beauty forming one

People's united thinking is the bouquet of voters will

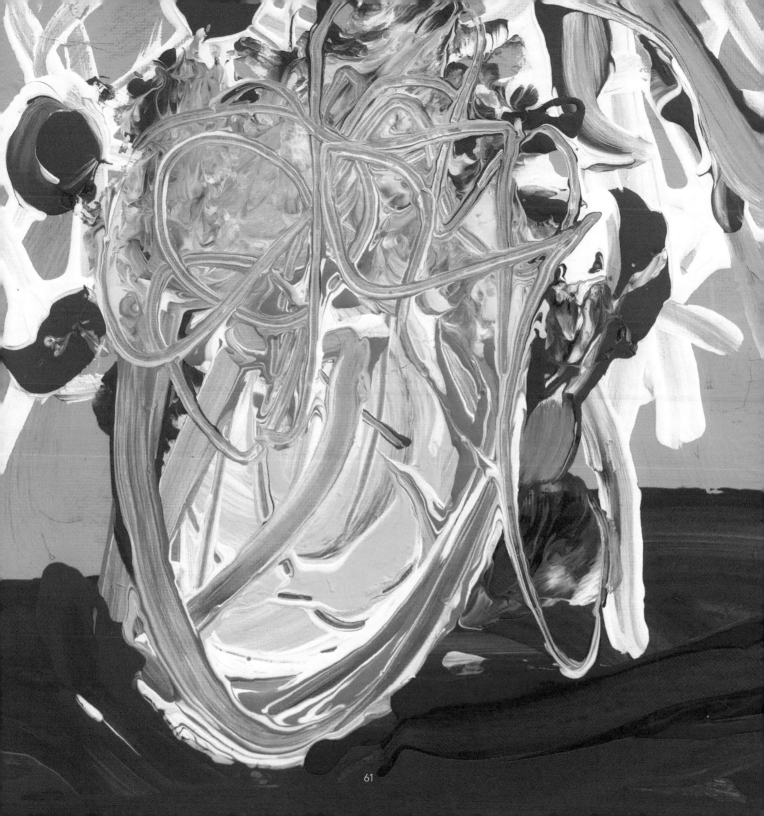

Trees Talking at Dusk

I watch the sun set the trees quietly away their branches

In the soft light they tell their story

How many birds came by

What the weather brought them

How the weather brought them

How the wind blew through their leaves

I listen for their voices in the stillness of that mysterious

time that falls between light and dark

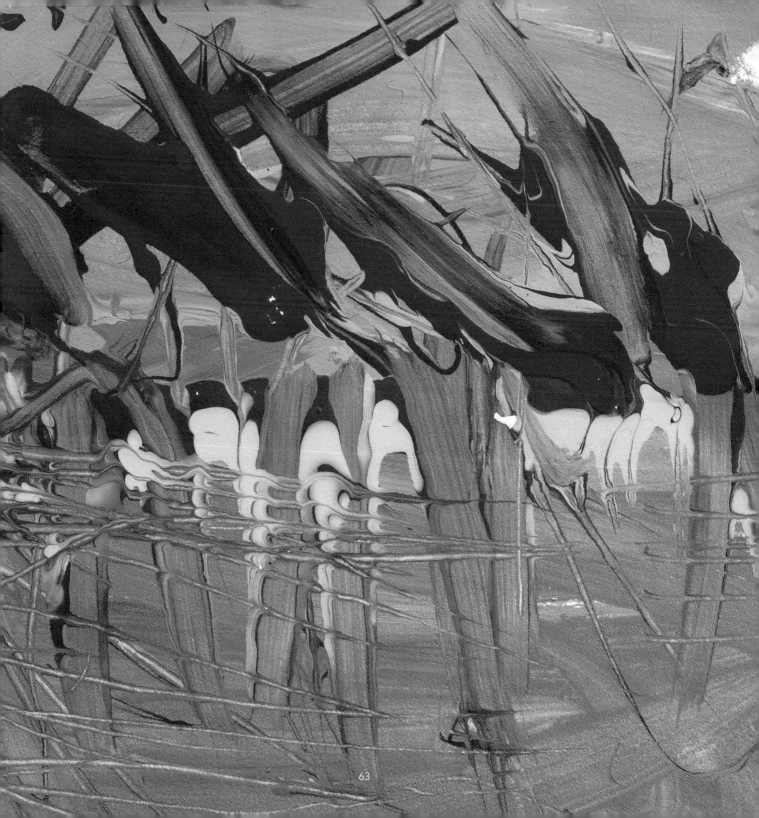

Roses in a Vase

Beautiful roses standing tall with purple pansies in a green vase
Looking through the window at the wonderful sunny day
I have to share with family and friends
Roses my favorite flower

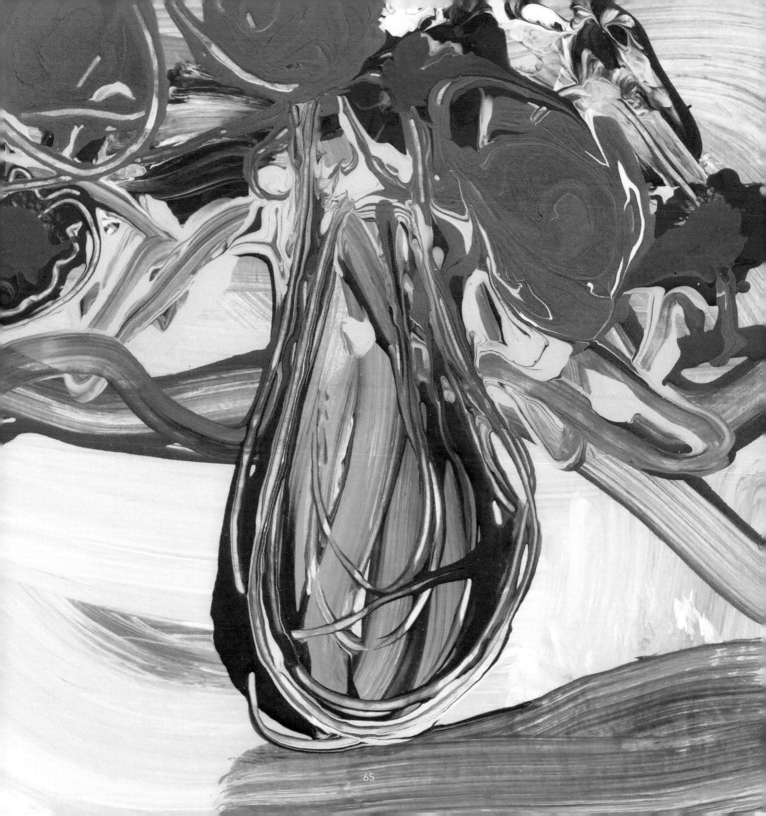

First Sky Night

The sky of fire burns so bright
It puts on a show in the evening light
Quick get your camera now it's gone
It comes and goes before you can know
The fire dims now as the sun sets slow
How low can it go maintaining it's glow?

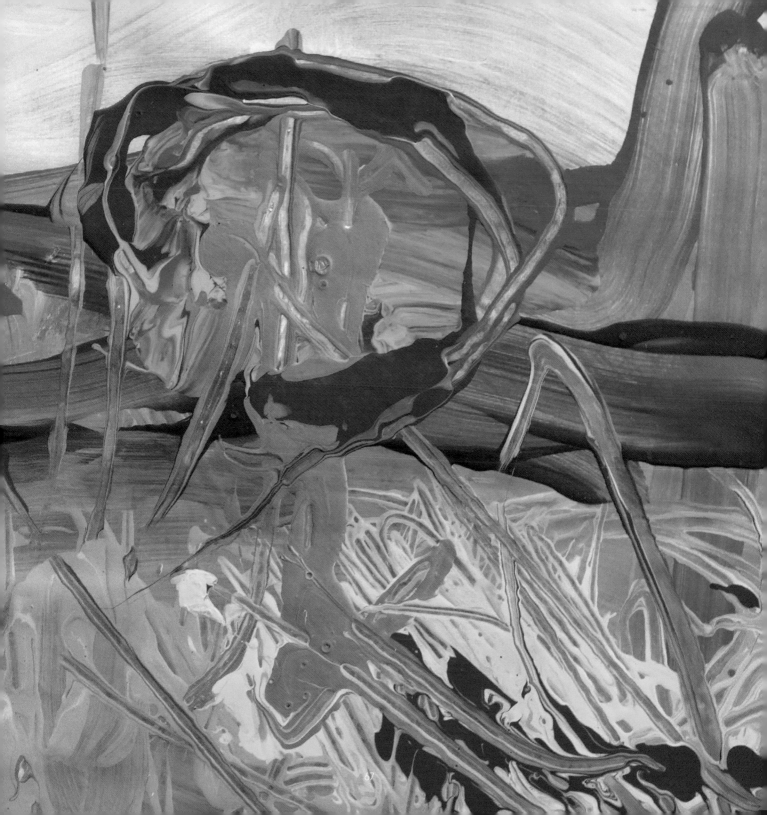

Paint it Again

The sky of fire burns so bright
It puts on a show in the evening light
Quick get a camera now it's gone
It comes and goes before you can know
The fire dims now as the sun sets slow
How low can it go maintaining its glow

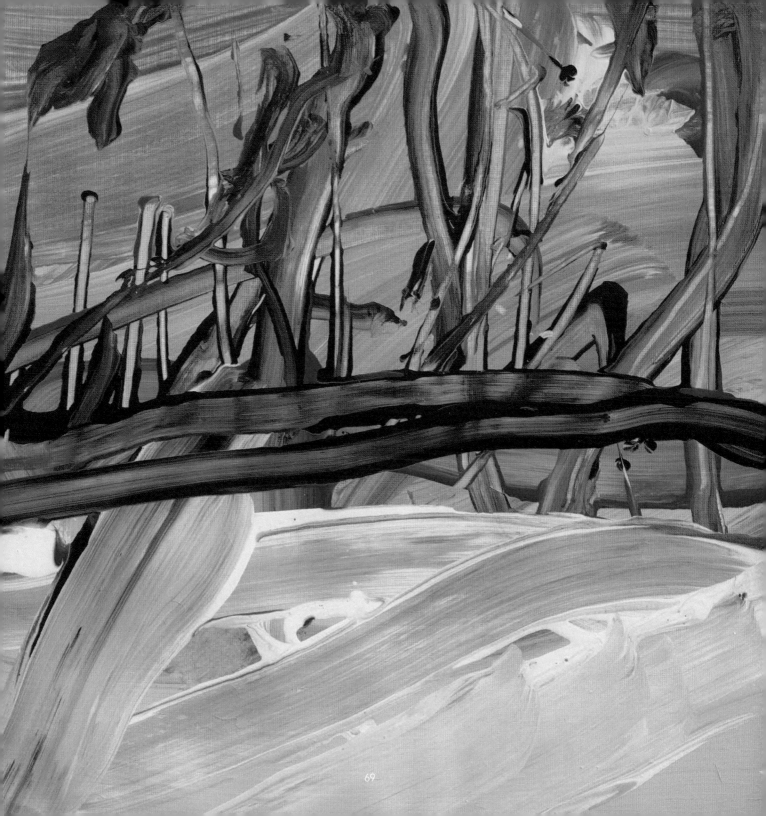

Fields of Joy

The flowers of spring live in my soul throughout the year

In Winters dark nights I recall the fields of beauty

The flowers bloom to restore my joy

In these fields I seek hope

Hope springs eternal in my joy

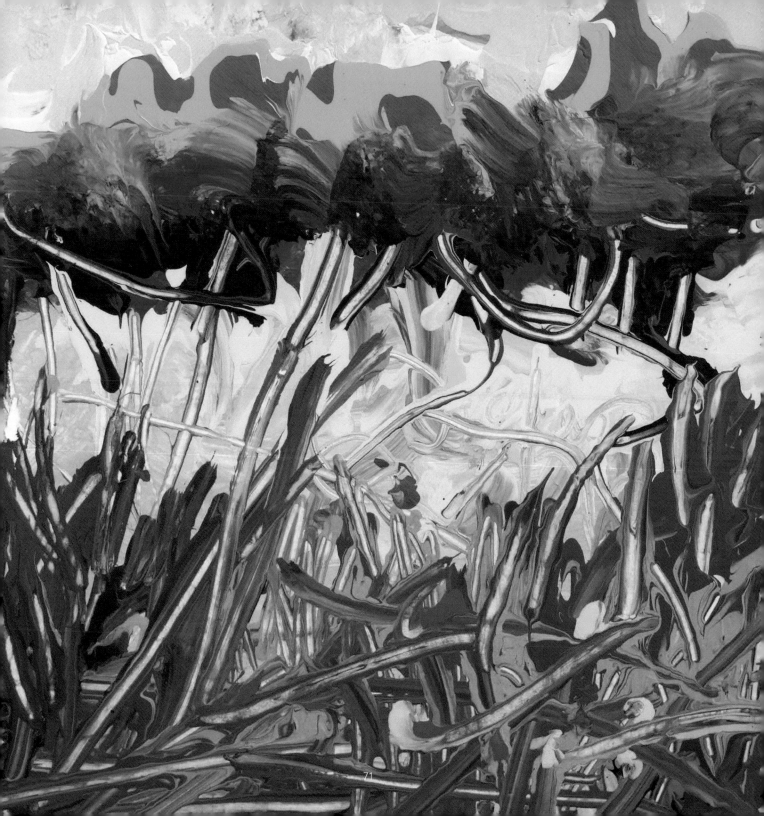

The Mighty Cypress

The wind swept cypress. A tree with sadness built in
It leans heavy branches out stretched for human-like hugs
The earth responds by blowing with force
Can you stand tall through it all?
The cypress responds with so much heart and soul
It tells us all to be strong through it all

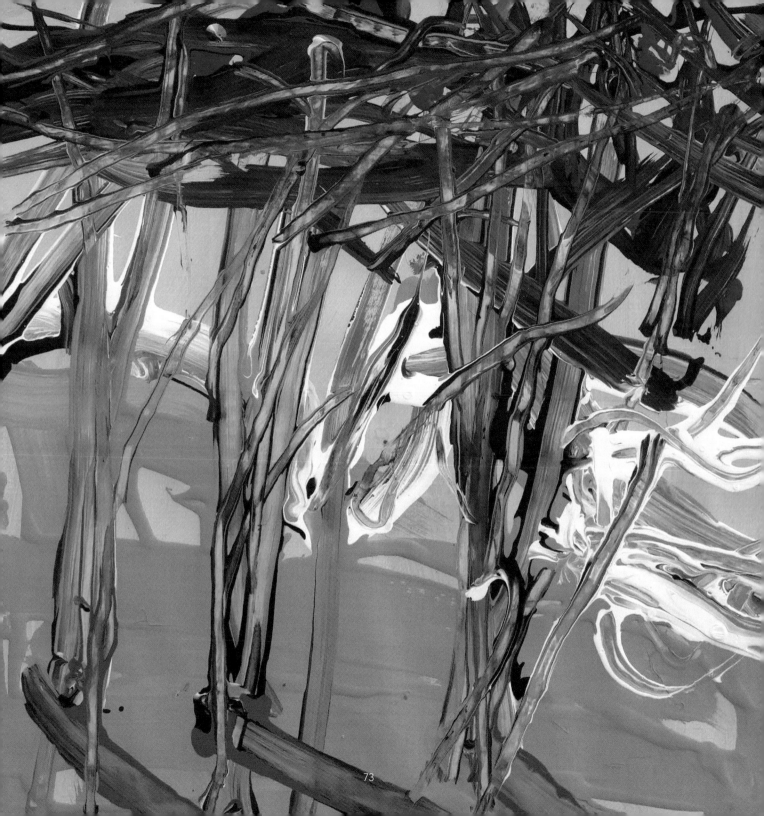

The Valley of Hope

The road up the mountain is so beautiful with brightly
colored flowers and hills, one of God's many gifts to me
I can't wait to get to the other side of the mountain to see what
beauty awaits for my eyes to see

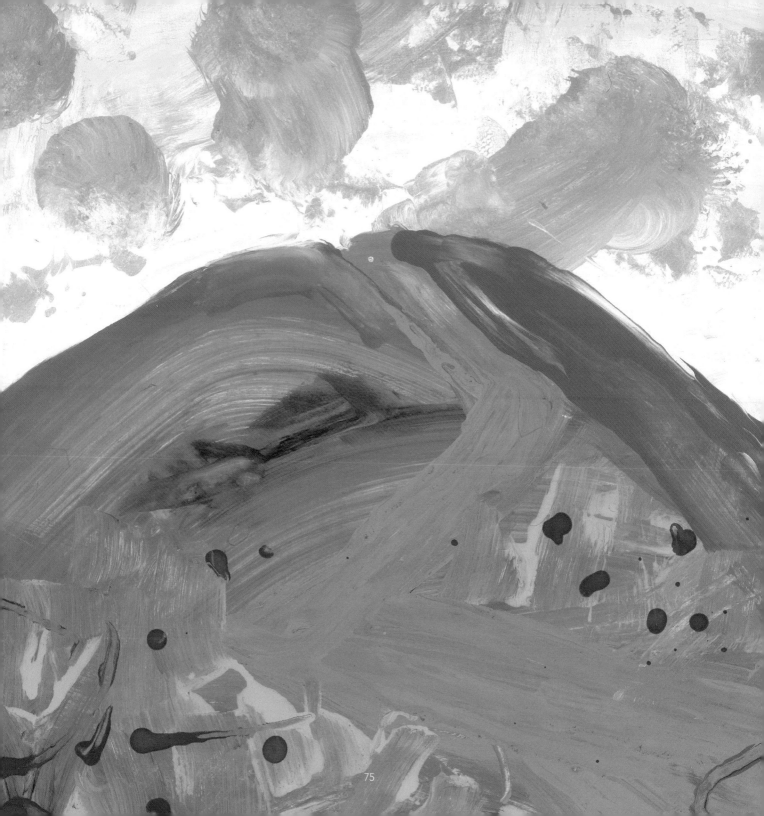

The Playground

The summer fun zone where life becomes a vacation

People enjoy the tropical breezes

The LaPaz playground full of sunny sand and heavenly joy

Peace lapping waves kiss the shore

Sunny smiles find people relaxing

The days pass without worry here

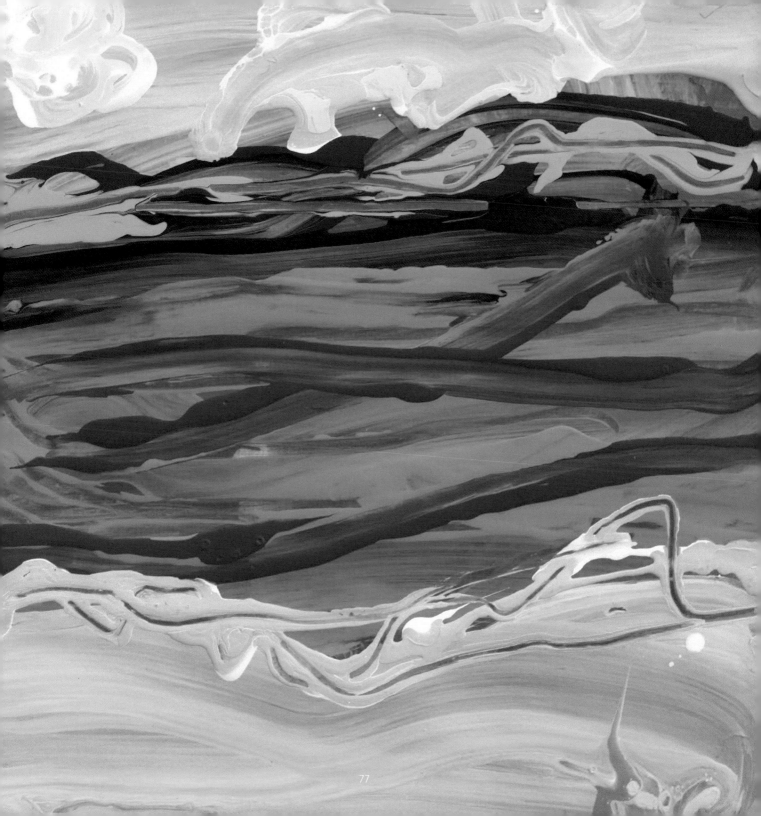

Light up the Day

The flowers of colorful joy fill my vase
The pansies with a smiling face
Cala-lillies so bright, they light up a life
I love a vase full of nature

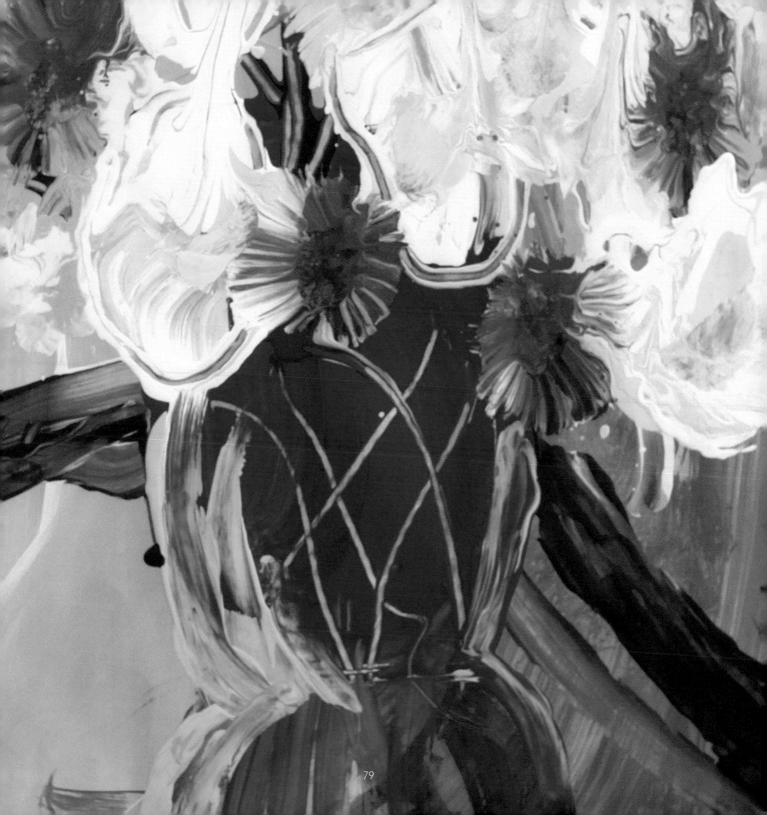

Stormy Resolution

Thunder roars as lightning cracks

The weather conversation loudly presents itself

Each side fighting for their voice

I am right...no I am right...no I am right

Listen to one another, seek the other's vision of truth

Find common ground Find peace

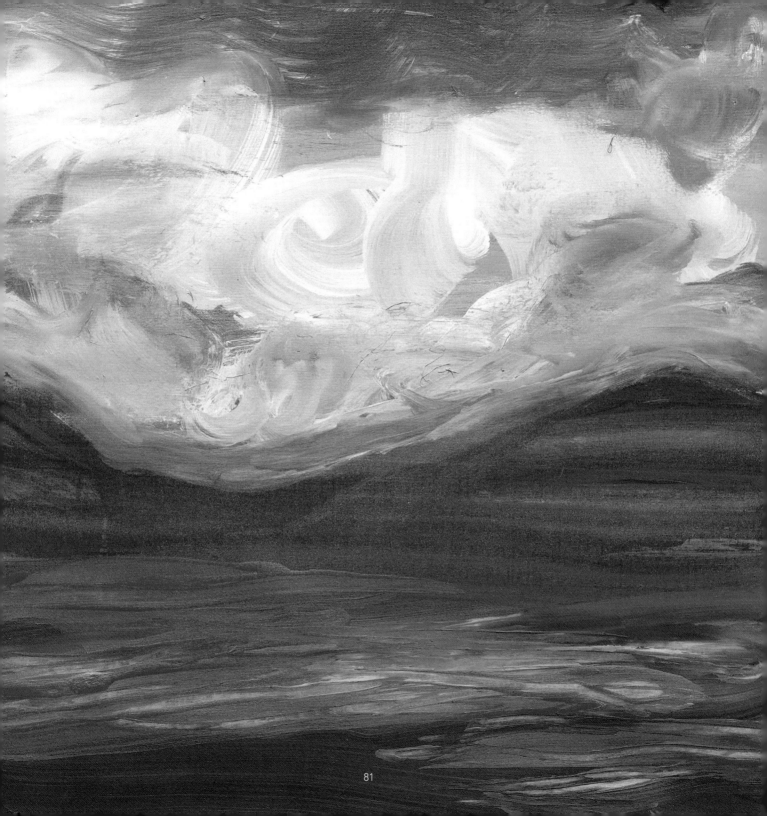

The Suns Heavenly Love

Hot heavenly heat rains, it's joyful warmth gives me love

Flowers standing tall soaking up the heat

Beauty finds joy in the sun's rays

Heaven rings happiness with the sun's heat

Pretty plants find love under the sun

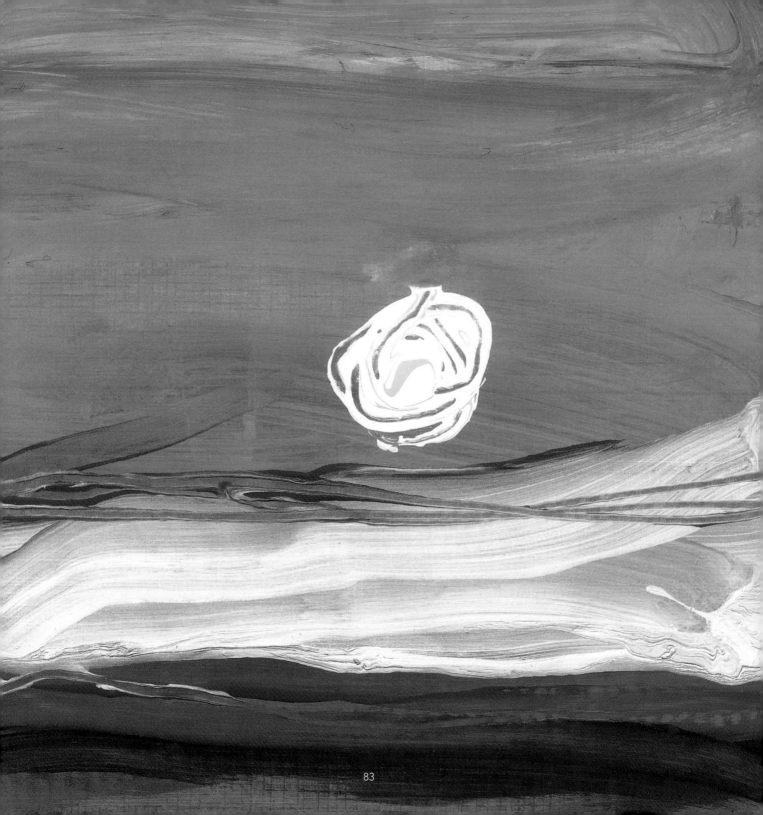

Tulip's Hope

Tulips are the flower that ushers in spring
Hopeful smiles appear when tulips are near
Happiness wells up inside as winter's ice melts
Fresh hope is always possible in tulip's bloom

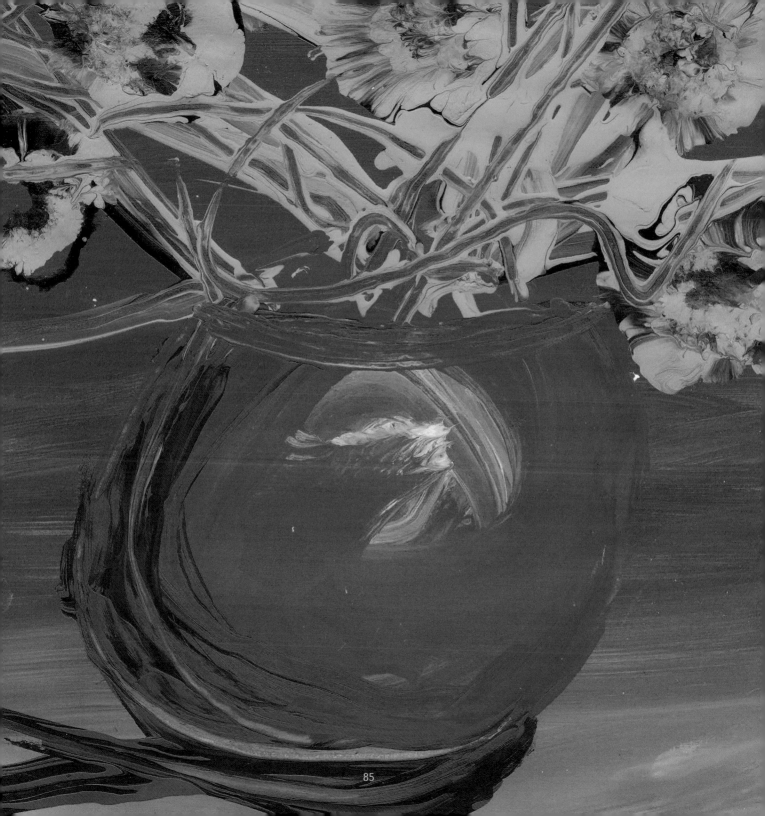

CPSIA information can be obtained at www.ICGtesting.com
Printed in the USA
BV1W12n1928270515
401598BV00004BA/7